FLORINE STETTHEIMER

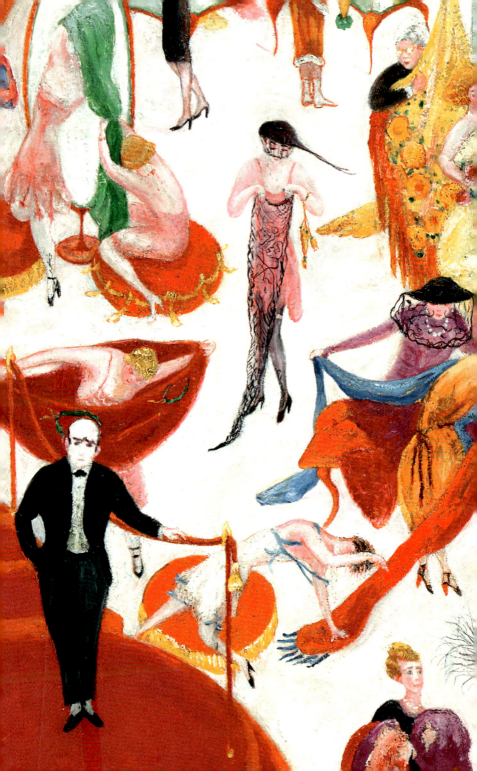

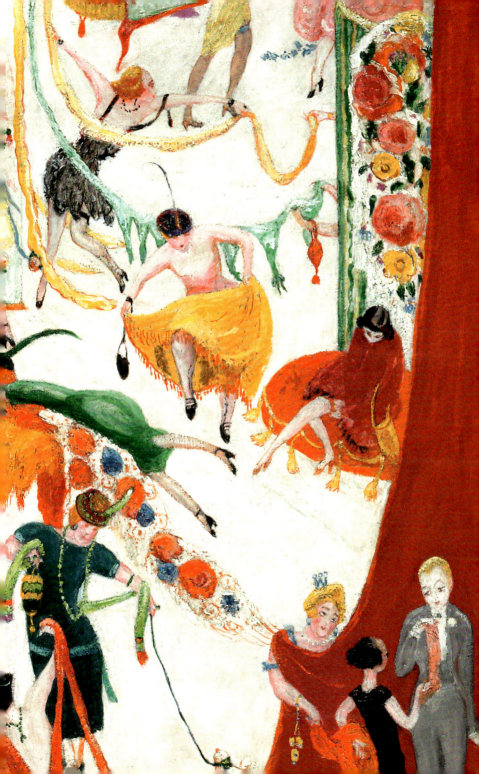

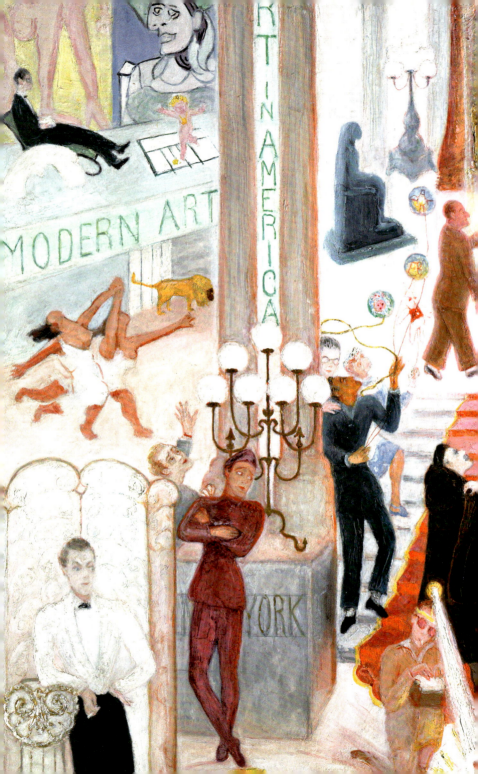

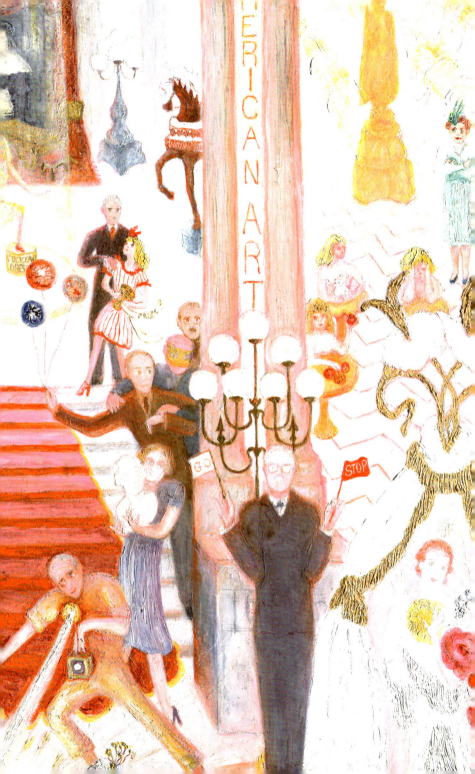

FLORINE
STETTHEIMER

Karin Althaus and Susanne Böller

LENBACHHAUS

HIRMER

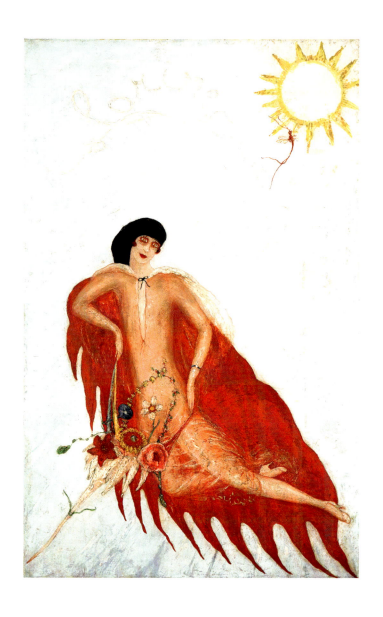

FLORINE STETTHEIMER
Portrait of Myself, 1923, oil on canvas
Art Properties, Avery Architectural & Fine Arts Library,
Columbia University, New York. Gift of the Estate of Ettie Stettheimer, 1967

CONTENTS

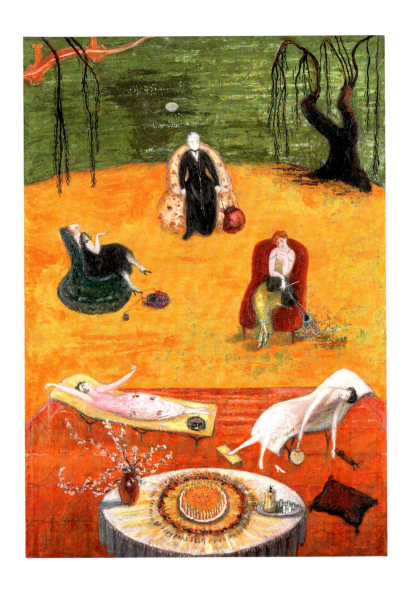

1 *Heat*, 1919, oil on canvas, Brooklyn Museum, New York.
Gift of the Estate of Ettie Stettheimer

"AT LAST GROWN YOUNG WITH NOISE AND COLOR AND LIGHT AND JAZZ"

Karin Althaus and Susanne Böller

Florine Stettheimer called her painting *Family Portrait II* (32) "my masterpiece."[1] It was the first painting to be seen by the public after her death on May 11, 1944—in the exhibition *Art in Progress*, celebrating the 15th anniversary of the founding of New York's Museum of Modern Art. Two years later, in 1946, that same museum devoted a retrospective to Florine Stettheimer put together by the grandees of New York's art scene at the time—initiated by Marcel Duchamp, curated by Monroe Wheeler, and with a catalogue essay by the art critic Henry McBride. The show was both a demonstration of friendly devotion and recognition of an extraordinary artist.

During her lifetime, Florine Stettheimer strictly controlled the public display of her work. Her first solo exhibition, at M. Knoedler & Co. in New York in 1916, proved to be her last. Disappointed by the critical and public response, she subsequently shied away from the art market, deliberately showing her work only in group exhibitions. She did, however, allow select circles of guests to admire her newest paintings in her atelier. The fact that she held herself aloof from the public and the market hampered the reception of her life's work, which would, at times, be known only to insiders; it would be temporarily forgotten, and then rediscovered.

Stettheimer incorporated in her art practice a special combination of painting, poetry, design, and staging—and with it opened up new possibilities in Modern art. Blurring the boundaries between genres and mediums, to this day her works particularly appeal to artists whose idea of painting extended beyond the stretcher, and who carry it over into installations or other fields such as fashion, performance, music, or social criticism. For a long time she was thought of as an artist for creative souls, an "artist's artist," prized for her glamour and her subversiveness. Andy Warhol was flabbergasted when his friend Henry Geldzahler, a curator at the Metropolitan Museum, showed him Stettheimer's series of four large *Cathedral* paintings in the museum's storeroom—a New York panorama immediately recognizable to both natives and tourists: Wall Street, Broadway and Fifth Avenue, The Museum of Modern Art, and Tiffany's (22–25). In her chronicle of "high and low" urban life, Stettheimer anticipated much that would later be of interest to Pop Art.

Elisabeth Sussman has called Florine Stettheimer's art "an antidote to the sterility of modernity."[2] Her pictures radiate an incredible generosity and love of life. It is a pleasure to study them, to "walk around in them," and to get to know the people in these mostly multi-figural paintings. Her figures are elegant, sophisticated, androgynous, queer, moonstruck, witty, and ambiguous. Even without an understanding of the many private and contemporary allusions, we are fascinated by the overall result. Stettheimer's contemporary Carl van Vechten, a fan of the Harlem Renaissance, saw her art as the essence of jazz: "The lady has got a very modern quality into her painting. … At the risk of being misunderstood, I must call this quality jazz."[3] In Stettheimer's work we can sense the ebullient spirit of the Roaring Twenties. Thanks to her passion for both the high life and popular culture, she was able to depict celebrities, picnics, bathing parties, beauty contests, and shopping sprees with genuine enthusiasm. In the 1930s, however, more problematic both economically and politically, a certain irony, a somewhat nostalgic way of looking at current events made its way into her work.

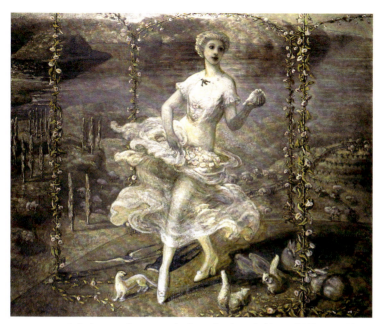

2 *Spring*, 1907, oil on canvas, Art Properties, Avery Architectural & Fine Arts Library, Columbia University, New York. Gift of the Estate of Ettie Stettheimer, 1967

TRAVELS AND TRAINING

It was in New York that Florine Stettheimer lived and practiced her art, which is seen to be wholly American. Yet the artist spent long periods of her life in Europe. She came from a well-to-do American Jewish family with German roots. Until the outbreak of the First World War she led a nomadic life with her mother Rosetta and sisters Ettie and Carrie, moving between longer sojourns in Germany, France, and Italy—bastions of high culture and art. She received first instruction in drawing in Stuttgart and Berlin, and became so proficient that in 1892, at age 21, she was accepted into New York's Art Students League. Her teachers, J. Carroll Beckwith, Harry Siddons Mowbray, and Kenyon Cox, had all studied in Paris, and practiced a decorative, academic style in their portraits, genre paintings, and nudes. At the League Stettheimer was able to work from nude models. She took part in exhibitions and was ultimately elected "corresponding

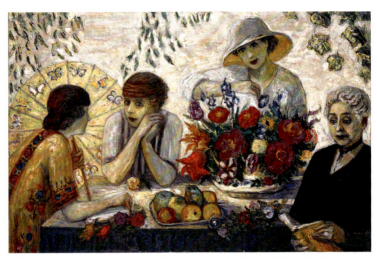

3 *Family Portrait I*, 1915, oil on canvas, Art Properties, Avery Architectural & Fine Arts Library, Columbia University, New York. Gift of the Estate of Ettie Stettheimer, 1967

secretary." This was her only advanced art-school training. Whenever she was in Paris or Munich for an extended stay she would engage private instructors. Nothing is known of any specific teachers of hers in Paris, but from her diary entries we know that while in Munich she focused on painting techniques.[4]

Equally important for her artistic development were visits to museums, exhibitions, and studios, her exposure to works by the old masters as well as contemporary art. These are documented both by her diary entries, ranging from the insightful to the zany, and by works like *Spring* (2)—an amusing, veiled self-portrait in which she deliberately slimmed down Sandro Botticelli's *Primavera*, having thought her too fulsome when she saw her in Florence, and clothed her in modern dress. The composition has something of Munich's *Jugendstil* about it, and ties in with a revival at the time of the Rococo genre of bucolic insouciance. Yet in her diary she noted: "My Flora is kitsch."[5] Until 1914 Stettheimer's work reflected the painting of Henri Matisse, both in style and in subject matter. With its strong colors and decorative patterns against a light background, her *Family Portrait I* (3) from 1915 combines the genres of the portrait and the still life.

When traveling the family not only sought out fine art; it also patronized theater and ballet, kept up with the newest novels and belles lettres, and followed trends in fashion, the decorative arts, and interior decoration. The women stayed in luxurious hotels or rented apartments—and studios for the painting daughter, which she decorated to her own taste. After their return to the United States, Stettheimer was able to indulge her passion for decorating to the full in their private apartments and her studio in the Beaux-Arts Building. It was only logical that she insisted on re-creating a salon-like setting for her one-woman show at Knoedler's in 1916. Since the public response to that show proved to be lukewarm at best, she subsequently chose to present her paintings in her own salon, where she staged special viewing parties for them. The same motivation led her to display certain works not in group shows but—like many other New York modern painters—in home-furnishing sections of high-end department stores.

ART AND CARNIVAL

Stettheimer first attempted to combine various different art forms in her ballet *Orphée of the Quat'z'Arts.* She conceived the work in 1912, and worked on it for years. She wrote the libretto and designed the figures and costumes for a Carnival parade. The work was inspired by a Paris performance by the Ballets Russes in early June 1912. The star dancer Vaslav Nijinsky had devised a choreography to Claude Debussy's *Prélude à l'après-midi d'un faune*, after motifs by Stéphane Mallarmé, featuring a faun's encounter with seven nymphs. Whereas the nymphs executed only minimal movements, Nijinsky himself, wearing a skin-tight, checkered costume, danced with abandon, like some primitive beast. Critics roasted the libidinous faun's performance, but artists loved it. Stettheimer was enchanted: Nijinsky was "archaic," the "most wonderful male dancer I have seen—and I imagine the rest or the world has never seen better." She also expressly mentioned the set designer Léon Bakst, who "is lucky to be so artistic and able to see his things executed."[6]

Even years later, Stettheimer would occasionally have Nijinsky "make an appearance" in her paintings—for example in *Music* (4). It was right after the performance that she began to outline her own fantastic ballet.[7] A Parisian Carnival tradition, the Bal de Quat'z'Arts (1892–1966), served as a

4 *Music*, ca. 1920, oil on canvas
Rose Art Museum, Brandeis University, Waltham, Massachusetts.
Gift of Mr. Joseph Solomon, New York

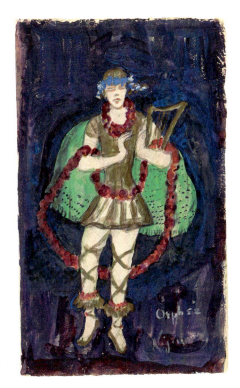

5 Costume Design (Nijinsky) for the ballet *Orphée of the Quat'z'Arts*, ca. 1912, gouache and metal pigment on paper, The Museum of Modern Art, New York. Gift of Miss Ettie Stettheimer, 1947

framing device. That annual extravaganza was organized by students at the École des Beaux-Arts, with its four schools for architecture, painting, sculpture, and engraving. Participants mainly wore antique costumes, and naked women also appeared in the tableaux vivants and bacchanalian reveling. The ball ended with a parade of floats to the Louvre and back to the École. It is possible that the Stettheimer sisters, who loved Carnival, had once taken part in it.

Stettheimer pictured a colorful procession of Greek gods and goddesses with their animal attendants, Saint Francis with animals, as well as historic figures. Orpheus, carrying his lyre, would dance with the chic young Georgette, Florine's alter ego. At dawn Mars was to enter on a white-gold "charger" and greet the rising sun with a dance.

Stettheimer designed all manner of striding, riding, and dancing figures (5–9) in watercolors, collages, and papier mâché. They frequently reveal an

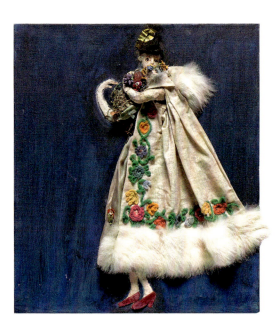

6 Costume Design (Georgette) for the ballet *Orphée of the Quat'z'Arts*, ca. 1912, oil, fabric, fur, yarn, and hair on canvas, The Museum of Modern Art, New York. Gift of Miss Ettie Stettheimer, 1947

indebtedness to Léon Bakst, most obviously in the Euridice entwined with a snake (7). Many of them are shown against a dark blue background, simulating the night sky of a stage set. Stettheimer constructed those slender, prancing figures that she pictured in her paintings with radiant colors and lavish use of the most varied materials—fabrics, silvered papers, wools, laces, furs, and beads. The ballet was never realized. It was only many years later that Stettheimer's cross-genre artistry would be brought to the stage as well.

7 Costume Design (Euridice) for the ballet *Orphée of the Quat'z'Arts*, ca. 1912, gouache, metal pigment, and pencil on paper
The Museum of Modern Art, New York. Gift of Miss Ettie Stettheimer, 1947

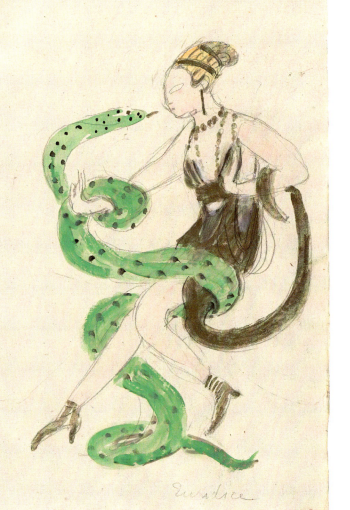

Eurydice

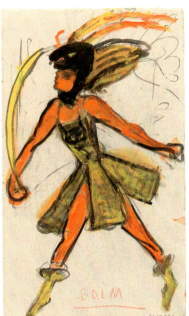

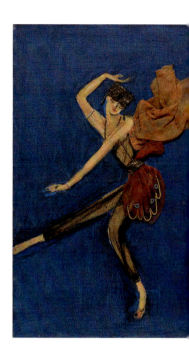

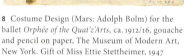

8 Costume Design (Mars: Adolph Bolm) for the
ballet *Orphée of the Quat'z'Arts*, ca. 1912/16, gouache
and pencil on paper, The Museum of Modern Art,
New York. Gift of Miss Ettie Stettheimer, 1947

THE AVANT-GARDE IN THE SALON

The Stettheimers returned to America in 1914, on the outbreak of the First
World War. With the exception of one single trip to Canada, Florine
Stettheimer would never leave the United States again. Her life now cen-
tered on New York, as she affirms in one of her poems: "Then back to New
York / And skytowers had begun to grow / And front stoop houses started
to go / And life became quite different / And it was as tho' someone had
planted seeds / And people sprouted like common weeds / And seemed
unaware of accepted things / And did all sorts of unheard things / And out
of it grew an amusing thing / Which I think is America having its fling /
And what I should like is to paint this thing."[8]

The returning artist also documented her patriotism in her painting *New
York / Liberty* (11). It shows the cityscape that greeted her as she arrived

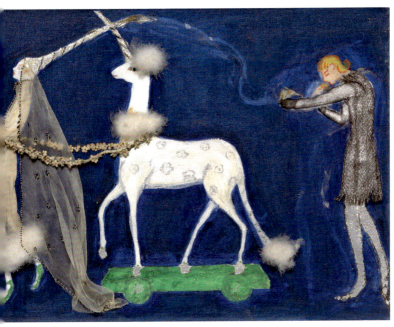

9 Costume Design (Procession: Zizim of Persia, Agnes de Bourganeuf, the Unicorn, and Pierre d'Aubusson) for the ballet *Orphée of the Quat'z'Arts*, ca. 1912, oil, fabric, beads on canvas, The Museum of Modern Art, New York. Gift of Miss Ettie Stettheimer, 1947

back in America by ship. The view sweeps across the deck of a flag-bedecked warship with President Woodrow Wilson, past the Statue of Liberty and other ships in the harbor toward an idealized skyline. National symbols like the Stars and Stripes and presidential memorabilia adorn many of her paintings.

Back in New York, Florine established one of the most cultivated modern salons with her mother and her equally unmarried sisters. At the same time—now in her mid-forties—she started her public career as an artist. In her pictures she underwent a rapid and exciting metamorphosis: she created a persona and art of her own out of the familiar and the new. She first painted the flowers that she now arranged daily in the family's apartment in New York and in the garden of a rented villa during the summer months. She lent them radiant, often miraculous life on canvas in her so-called "eyegays." Next came portraits of the immediate family members

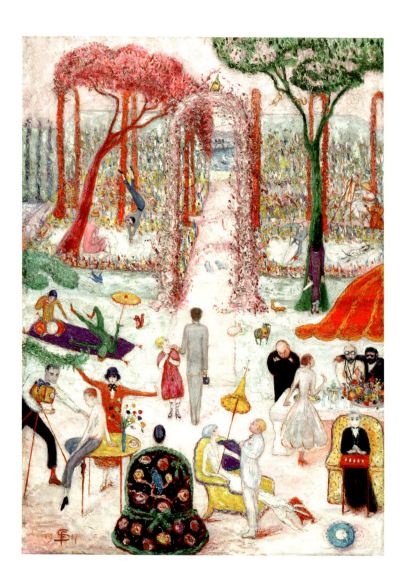

10 *Sunday Afternoon in the Country*, 1917, oil on canvas
The Cleveland Museum of Art. Gift of Ettie Stettheimer

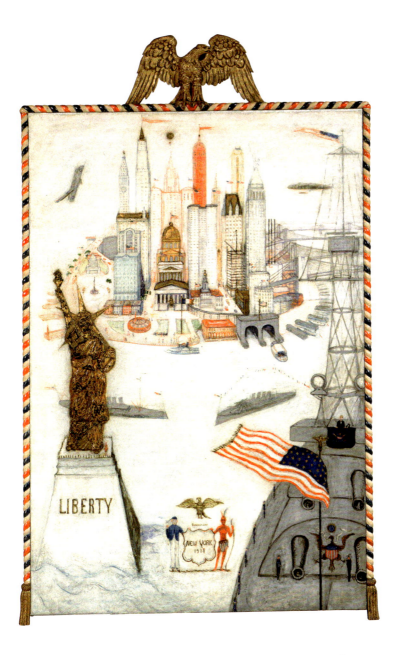

11 *New York / Liberty*, 1918/19, oil on canvas
Whitney Museum of American Art, New York

and some of their frequent guests, comprising a virtual *histoire de famille*. Family members were always present, even if her mother Rosetta only played solitaire at the edge of a gathering. The stylishly furnished salons of their apartments on New York's Upper West Side and the country houses they rented for the summer became the settings for a variety of entertainments. In one of her poems Stettheimer points out the close connection between the festivities and the pictures: "Our Parties / Our Picnics / Our Banquets / Our Friends / Have at last – a raison d'être / Seen in color and design / It amuses me / To recreate them / To paint them."[9]

These somewhat theatrically staged paintings generally picture a number of wispy, elegant, often androgynous figures moving about. What appears as though captured in simplified form on the spot was in fact drawn with great precision. Light, often white backgrounds set off the ornamental figures painted in radiant colors. Such are the effective components of the campy aesthetic that has made Stettheimer so interesting to later artists. Many of the guests were artists who had either emigrated from Paris during the war years or returned from there to the United States to make a new start. Marcel Duchamp, Albert Gleizes, Gaston Lachaise, Francis Picabia, and Maurice Sterne were dazzled by the mechanization and fast pace of the American metropolis, and the art-conscious public was thrilled that for the first time in history the Paris art scene had found its way to New York.[10]

At the Stettheimers' salon these emigrés met such representatives of the New York and international avant-garde as the artists Elie Nadelmann, Charles Demuth, and Georgia O'Keeffe, the film director Adolfo Best-Maugard, the writers Avery Hopwood and Carl van Vechten, the critics Henry McBride and Leo Stein, the director of a modern dance school Elizabeth Duncan, and the dancer Adolph Bolm. Carrie supplied the elegant refreshments, and Ettie assured lively conversation. The artists were mainly attracted by Florine and her paintings. The Stettheimer salon provided important artistic and intellectual stimuli: anything that was said there about modern art would sooner or later find an echo somewhere in the city.[11]

In the early 1920s Stettheimer painted extravagant portraits of her male friends. Instead of having her subjects sit for her, she created imaginary portraits of them in the isolation of her studio. What mattered was not the physical likeness, for regardless of their actual appearance almost all of them are pictured as slender, androgynous figures. Instead it was the joke, the combination of a characteristic pose with allusions to the man's interests, foibles, achievements, and shortcomings which of course only the initiated would understand.

Henry McBride was one of the first of her "models" (12). One summer, when the "Stetties" were rusticating near Sea Bright, New Jersey, he closely followed a tennis tournament there, and accordingly he is pictured here in the role of a line judge. We also see him seated high above the lawns wearing the traditional white trousers and dark jacket, and again painting the fence at his farm in Pennsylvania—in letters to Stettheimer he had complained about the tediousness of the process. Finally, he appears at the top as a pink figure with a cane, seen from the back, gazing at works by his favorite artists: from left to right a floral still life by Stettheimer, a female nude by Gaston Lachaise, a church by Charles Demuth, a watercolor by John Marin, and a seascape by Winslow Homer. Stettheimer thus not only mocked McBride as a tennis fan and do-it-yourselfer, but also recruited him as an admirer of her own art.

McBride judged the portrait of Marcel Duchamp (14) to be the most quirky of these portraits of friends.[12] The Stettheimer sisters supported "Duche," newly arrived from Paris in 1915, by employing him as a "French teacher." For his 30th birthday they organized a celebration that Florine also painted. Duchamp greatly admired her as a painter, and she, in turn, marveled at his ease and daring. In this portrait, unlike the others, she meant to create a likeness; the initials "MD" in the decor of his chair and the specially crafted frame help to establish his "brand." Duchamp delighted in creative puzzles, and naturally Stettheimer pictured him engaged in a highly allusive activity: he is seated as the creation of his own art in an almost empty room, and by way of a corkscrew-like mechanism he is manipulating his female alter ego: Rrose Sélavy (which can also be read as: Éros, c'est la vie). The clock with three hands, Duchamp explained, was meant to refer to his discussion with Stettheimer about the fourth

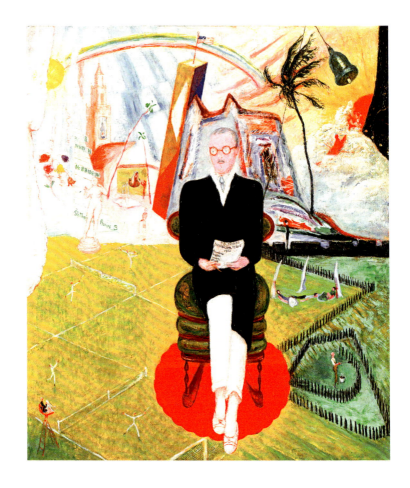

12 *Portrait of Henry McBride*, 1911, oil on canvas
Smith College Museum of Art, Northampton, Massachusetts.
Gift of Ettie Stettheimer, 1951

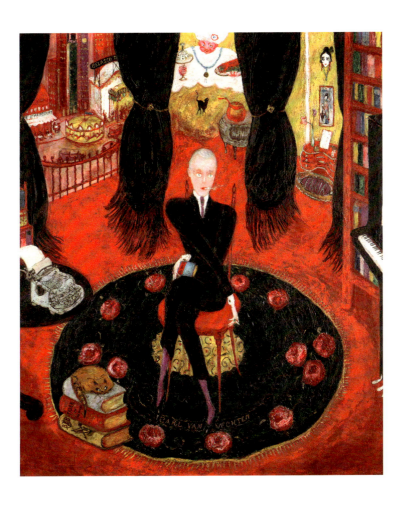

13 *Portrait of Carl van Vechten*, 1922, oil on canvas
Yale University Art Gallery, New Haven, Connecticut

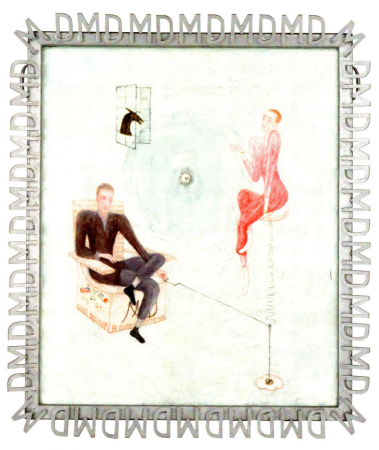

14 *Portrait of Marcel Duchamp*, 1923, oil on canvas
Private collection

dimension. It could also point to his passion for chess, like the horse's
head—unless this is the head of a laughing donkey, the emblem of the
Société Anonyme. The large circle around the clock recalled Duchamp's
optical experiments with rotating glass plates. Stettheimer's poem *Duche*
offers only limited clarification: "A silver-thin thin spiral / Revolving from
cool twilight / To as far as pink dawn / A steely negotiation of lightning /
That strikes / A solid lamb-wool mountain / Reared into the hot night /
And ended the spinning spiral's / Love flight."[13]

Stettheimer's setting for the photographer, writer, and music and dance critic Carl van Vechten (13), by contrast, is distinguished by a *horror vacui*. Van Vechten was an important mediator of the popular culture that found its way into Florine Stettheimer's images and poems. In the previous year he had published the biography of his alter ego Peter Whiffle, in which he himself also appeared, and in her painting Stettheimer referred to both the real personality and the fictional one.[14] The writer Whiffle explains that great art is descriptive, that it comprises a cataloguing of life, a summary in objects. In the biography actual friends appear, including Stettheimer: Van Vechten urges Whiffle to visit the artist in her studio. Instead, Whiffle buys an Aubusson rug adorned with roses, which the artist depicts in the center of her painting. She also includes herself by way of the typewriter keys, which spell out her name. Van Vechten's cats, his piano, and his books are not forgotten. In the background he appears as cook and host. Allusions to his wife, Fania Marinoff, are equally numerous; her face appears on the Nō mask hanging on the wall on the right.

THE AMERICAN WAY OF LIFE

Fascinating aspects of contemporary culture began to appear increasingly in Stettheimer's works. Although she celebrated both the popular and the exclusive, she maintained a "sophisticated" distance from modern, commercial amusements. The critic Paul Rosenfeld praised her "witty and satirical apotheosis of popular American art."[15] Her pictures are characterized by both fascination and critical observation. Just below their decorative, vibrant surfaces yawn social depths, the realities of racial, confessional, and class divisions. Thanks to her detailed analyses, her portrayals become sociological portraits of contemporary society. In tableaux teeming with figures she captured "typically American" leisure activities, for example boating and swimming, also featured in films from the 1920s,

following double page:
15 *Lake Placid*, 1919, oil on canvas
Museum of Fine Arts, Boston.
Gift of Miss Ettie Stettheimer

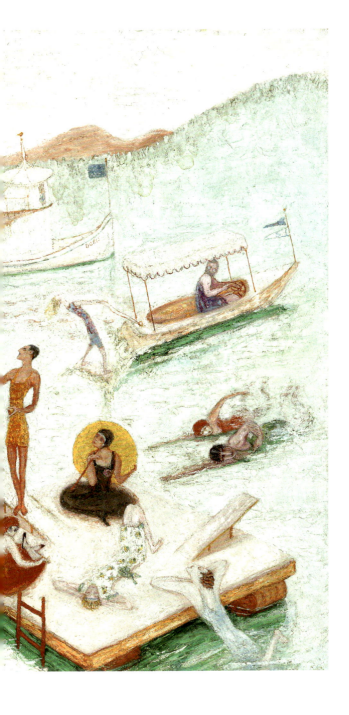

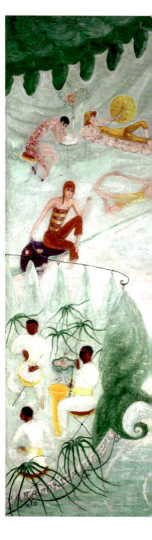

16 *Natatorium Undine*, 1927, oil and encaustic on canvas
The Frances Lehman Loeb Art Center, Vassar College,
Poughkeepsie, New York. Gift of Ettie Stettheimer, 1949

whether in upstate New York, where well-to-do urbanites frolicked on *Lake Placid* (15) or in *Natatorium Undine* (16), patterned after the fantastic swimming pools in East Coast luxury hotels. *Beauty Contest* (17) was dedicated to P. T. Barnum, the originator of the beauty contest, a spectacle first presented in Atlantic City in 1921. In 1924 it culminated in a mega-event at

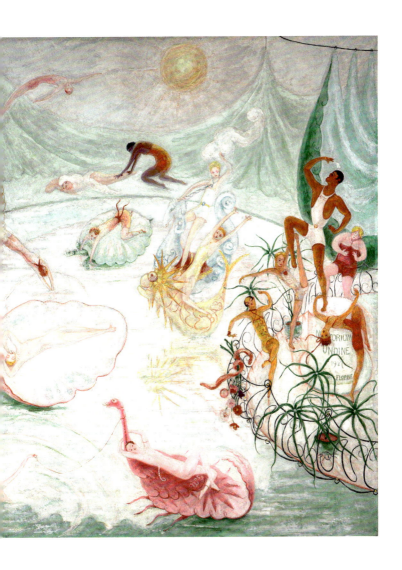

which some 300,000 people witnessed the crowning of Miss America. Another picture turned the *Spring Sale at Bendel's* (18) on Fifth Avenue into a painterly event. The three extravagant Stettheimer sisters were tireless shoppers for the fashions of European couturiers carried exclusively by Bendel's. Society ladies thronged the store in their thirst for bargains.

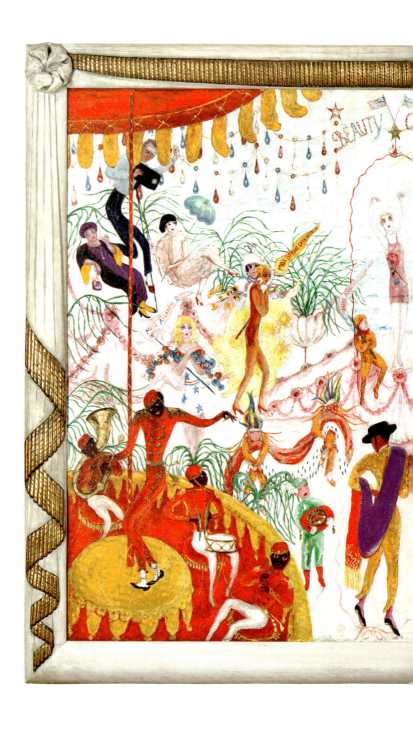

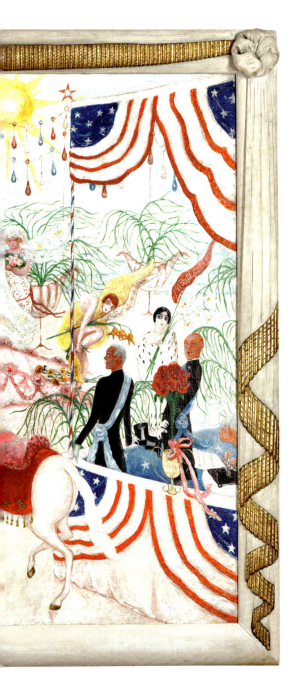

17 *Beauty Contest: To the
Memory of P. T. Barnum,*
1924, oil on canvas
Wadsworth Atheneum,
Hartford, Connecticut

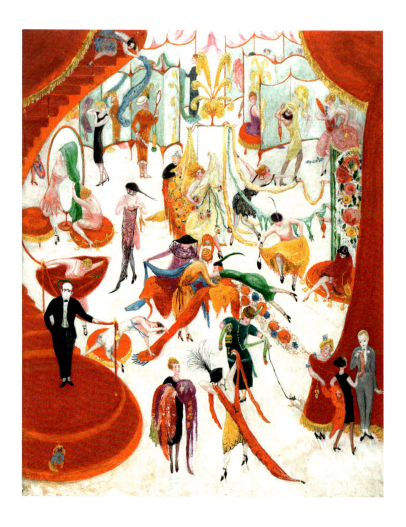

18 *Spring Sale at Bendel's*, 1921, oil on canvas
Philadelphia Museum of Art. Gift of Miss Ettie Stettheimer, 1951

Asbury Park South (19) is assuredly one of Stettheimer's most astonishing paintings. The elegant white Bohème is surveying a stretch of the New Jersey coastline where in segregated America African-Americans were permitted to amuse themselves near and in the ocean. The main observer of the scene, probably the organizer of the excursion, was Carl van Vechten, who can be seen on the viewing stand. His active promotion of African-American cultural figures made him an important, but not uncontroversial figure of the so-called Harlem Renaissance. The painting itself constitutes a degree of uncomfortable criticism of the man. In it whites and blacks are depicted with equal empathy, to be sure, yet the outing, which would have been impossible had the roles been reversed, seems like an ethnological inspection tour. Stettheimer focused her attention on the liveliness of the scene, rendering it as altogether positive; the injustice of racial segregation and its social and political consequences are not the subject of the picture.

A MODERN OPERA

In 1929 the American composer Virgil Thomson sought support in the salons of Carl van Vechten and Florine Stettheimer for his opera *Four Saints in Three Acts*. He had composed it in Paris to a libretto by Gertrude Stein—a parable on the purity of the life of artists reflected in the religious devotion of saints. For want of American saints, they are all from Ávila in Spain.

Stein's tautological prose does not advance a narrative, but rather expands like a sprawling landscape perceived all at once. When setting it to music Thomson simply responded to the sound of her words and the grammar of the text including the stage directions. With its reminiscences of American rhythms and spirituals, the score is melodically a rather conventional oratorio.[16]

following double page:
19 *Asbury Park South*, 1920, oil on canvas
collection of halley k harrisburg and
Michael Rosenfeld, New York

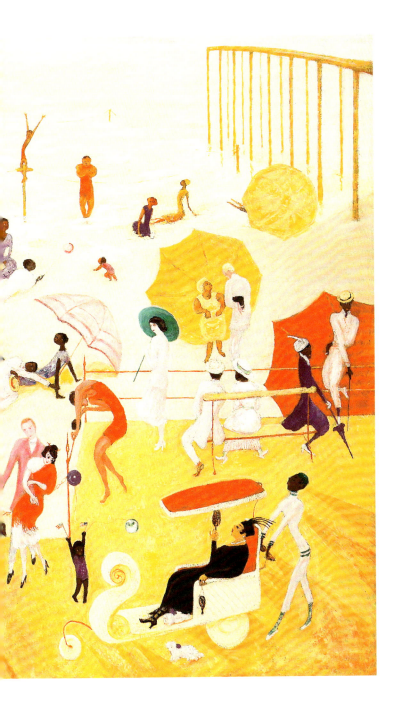

Thomson had first intended that Pablo Picasso design the sets and costumes, but when he saw Stettheimer's paintings and her idiosyncratically decorated atelier he was convinced that her campy aesthetic would lend this modern opera about sainthood an appropriate earnestness as well as the necessary levity.

Stettheimer created miniature stage sets and costumes for three-dimensional figures she made herself (20, 21). She gave each of the two dozen figures an expressive pose, and constructed miniature architecture, furniture, and blue cellophane backdrops. She also produced a poem and a "portrait" about Thomson and Stein's opera. Her multimedia concept was extremely stringent. Whereas in the first act the stage was illuminated with the brightest of white light, in the following ones it was flooded in different colors.

Thomson also engaged other career changers who gave to the opera their all. His decision to cast it with African-American performers was crucial. He was rightly convinced that African-American singers and dancers working in Harlem and on Broadway would interpret the text and music most effectively.

A group of "high bohemians," among them salonières like the Stettheimers, the Harvard Modernists, and New York critics helped to make the modern chic of *Four Saints* a success. The premiere took place on February 7, 1934, at the Wadsworth Atheneum in Hartford, Connecticut. Enthusiastically received, the opera then moved to Broadway and later to Chicago. Thanks to the work of noted photographers—including Carl van Vechten, Lee Miller, and George Platt Lynes—this innovative project in defiance of all theatrical convention was well documented and widely celebrated, and to this day it stands as a milestone in modern performance practice.[17]

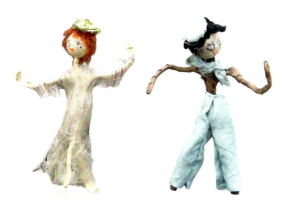

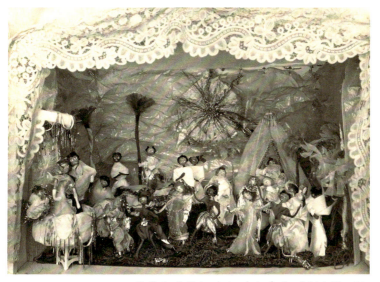

21 Florine Stettheimer's stage design for *Four Saints in Three Acts*,
photo: Peter A. Juley & Son, Yale Collection of American Literature,
Beinecke Rare Book & Manuscript Library, New Haven, Connecticut

NEW YORK'S "SACRED INSTITUTIONS"

Florine Stettheimer's four large-format *Cathedrals* (1929–1942) form a final
high point in her work. They illustrate core "sanctities" of modern life, the
figures and social implications of the worlds of entertainment, finance,
fashion, and the arts.

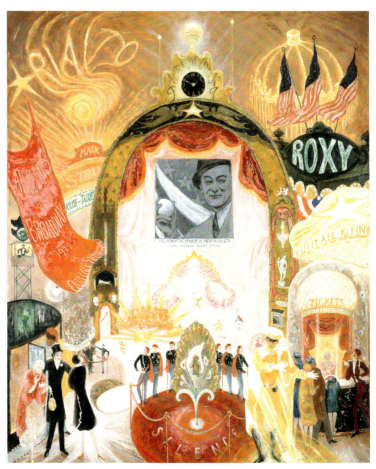

22 *The Cathedrals of Broadway*, 1929, oil on canvas
The Metropolitan Museum of Art, New York. Gift of Ettie Stettheimer

The painting *The Cathedrals of Broadway* (22) captures the magical atmosphere of neon-lit theaters. In the Depression years entertainment in the form of film and live performances proved to be an ideal escape from reality. As in *Spring Sale at Bendel's* (18), *The Cathedrals of Fifth Avenue* (23) casts an affectionate eye on High Society and high-end consumerism. There is little trace of the far more restrictive lives most New Yorkers were forced to live. In 1932, when the painting was first shown in an exhibition

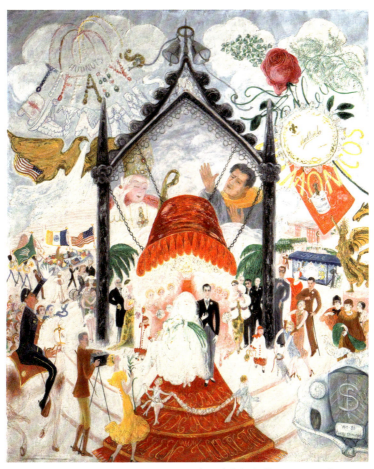

23 *The Cathedrals of Fifth Avenue*, 1931, oil on canvas
The Metropolitan Museum of Art, New York. Gift of Ettie Stettheimer

by the American Society of Painters, Sculptors, and Gravers at the Whitney Museum of American Art, Henry McBride wrote: "Miss Stettheimer's *Cathedrals of Fifth Avenue* must be the most modern in method of all these pictures, for it is *cinematic*, historic, fantastic, realistic, mocking, affectionate, calligraphic, encyclopedic, Proustian and even portentous. In fact, it has everything and everything in proportion."[18] *The Cathedrals of Wall Street* (24) combines American icons—from George Washington, whom

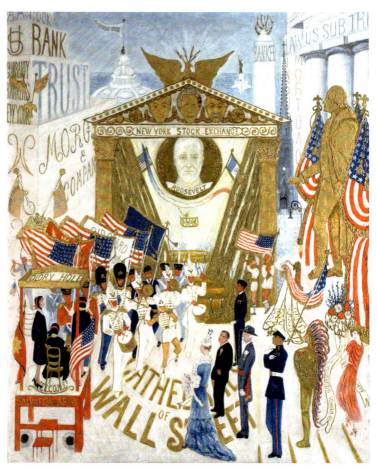

24 *The Cathedrals of Wall Street*, 1939, oil on canvas
The Metropolitan Museum of Art, New York. Gift of Ettie Stettheimer

Stettheimer venerated, to Franklin Delano Roosevelt, whose New Deal policies she applauded—and the highly symbolic self-promotion around the financial center of Wall Street with recent impressions from the New York World's Fair of 1939/40.

In early 1942 Stettheimer began to work on *The Cathedrals of Art* (25), which would remain unfinished. With her intimate knowledge of the rich New York art scene and a rapier wit, she described its various activities

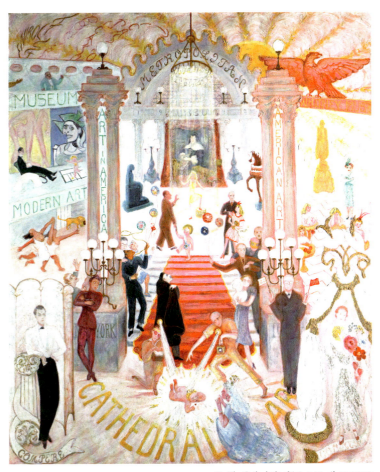

25 *The Cathedrals of Art*, 1942, oil on canvas
The Metropolitan Museum of Art, New York. Gift of Ettie Stettheimer

and rivalries, exemplified by the directors of the prominent institutions
The Metropolitan Museum, The Museum of Modern Art, and The Whitney
Museum of Modern Art.

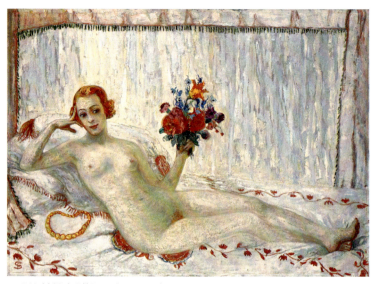

26 *A Model (Nude Self-Portrait)*, ca.1915, oil on canvas, Art Properties,
Avery Architectural & Fine Arts Library, Columbia University, New York.
Gift of the Estate of Ettie Stettheimer, 1967

FOREVER YOUNG

Florine Stettheimer included herself in many of her pictures; she functions
as author and observer and is herself observed. For example, she appears
in all four of the *Cathedrals*. In *Cathedrals of Broadway* (22) she is visible at
lower left along with her sister Stella Wanger and the latter's son outside a
club entrance. She pictures herself from the back wearing a black coat and
red shoes, gazing up at the spectacle in the center of the picture. In
Cathedrals of Fifth Avenue (23) Stettheimer and her friends are witnessing a
celebrity wedding; with her sisters Ettie and Carrie she has just emerged
from a limousine, this time in the lower right corner. In the Wall Street
panorama (24) she again stands at lower right, S-shaped, slender, wearing
a red dress and red shoes, and carrying a wreath of flowers to adorn the
statue of George Washington. In the unfinished *Cathedrals of Art* (25),
finally, she appears as the event's hostess, or *commère*, across from its
compère, the interior designer Robert E. Locher. In all four pictures,
painted over the course of thirteen years, Florine Stettheimer's figure

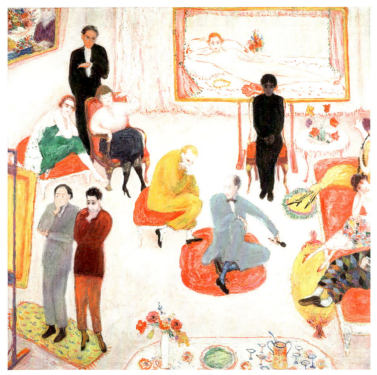

27 *Studio Party (Soirée)*, ca. 1917–19, oil on canvas
Yale University Art Gallery, New Haven, Connecticut

appears youthful, with short red hair and red shoes sending out erotic
signals. She is dressed in a style reminiscent of the androgynous *garçonnes*
of the Twenties and yet seemingly timeless. She is always a participant, but
only in the margins, never at the center.

Despite her advancing age, we find this striking youthfulness in
Stettheimer's self-portraits as well. The painting *A Model* (26), in which
she appears as a recumbent nude in large format, is perhaps the most spec-
tacular of them. Traditionally, female nudes were painted by male painters
for male viewers. Stettheimer ironically quotes Édouard Manet's *Olympia*
(1863), that scandalous nineteenth-century painting of a famous courte-
san. In her self-portrait she is at one and the same time creator and con-
fident nude model. She never showed the painting in public during her

28 *Portrait of My Mother*, 1925,
oil on canvas, The Museum of
Modern Art, New York,
Barbara S. Adler Bequest, 1971

lifetime, but featured it prominently in the *Studio Party (Soirée)* (27) painted a short time later. That work pictures one of her "birthday parties" in celebration of a new painting. In the foreground the French artists Albert Gleizes and Gaston Lachaise contemplate a work on an easel turned away from us. Other guests are Ettie Stettheimer, Isabelle Lachaise, Maurice Sterne, Avery Hopwood, Leo Stein, and possibly the Hindu poet Uday Shankar. Only Juliette Gleizes, seated on a sofa across from the painted nude, appears to be pondering its resemblance to her hostess.

In 1923 Florine Stettheimer painted portraits of her two sisters and herself. In the fairly realistic *Portrait of My Sister, Carrie W. Stettheimer* (29), Carrie, dressed in the most fashionable Twenties style, stands in front of the famous dollhouse she worked on for roughly two decades and for which she was given works of art in miniature format by artist friends. The

29 *Portrait of My Sister, Carrie W. Stettheimer*, 1923, oil on canvas on masonite
Art Properties, Avery Architectural & Fine Arts Library, Columbia University, New York.
Gift of the Estate of Ettie Stettheimer, 1967

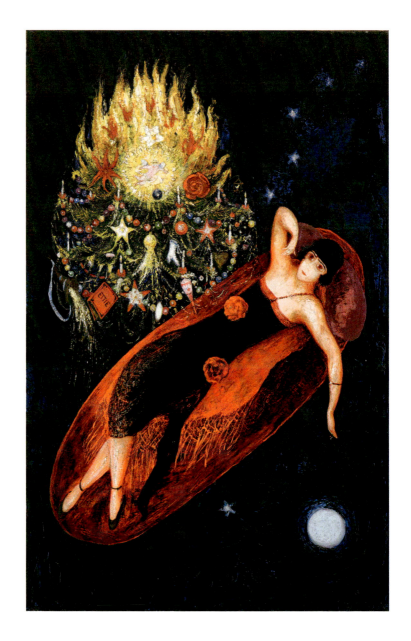

30 *Portrait of My Sister, Ettie Stettheimer*, 1923, oil on canvas on masonite
Art Properties, Avery Architectural & Fine Arts Library, Columbia University, New York.
Gift of the Estate of Ettie Stettheimer, 1967

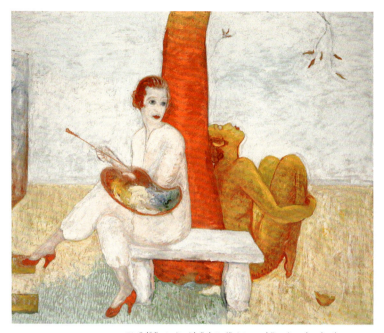

31 *Self-Portrait with Palette (Painter and Faun)*, undated, oil on canvas
Art Properties, Avery Architectural & Fine Arts Library, Columbia University, New York.
Gift of the Estate of Ettie Stettheimer, 1967

Portrait of My Sister, Ettie Stettheimer (30) presents us with a less realistic likeness: Ettie is lounging on a huge cushion against a night sky. A flaming Christmas tree holds a reference to her literary activity. *Portrait of Myself* (p. 8) is the most surreal of the three. It pictures an idealized Florine Stettheimer: young, intellectual, with a black beret, in a flimsy dress, with flaming red accents against a radiantly white background. Her slender body resembles that of the red dragonfly winging toward the sun, in front of which we read the name "Florine." The painting is a clear statement of how she wished to be seen as a female artist.

following double page:
32 *Family Portrait II*, 1933, oil on canvas
The Museum of Modern Art, New York.
Gift of Miss Ettie Stettheimer, 1956

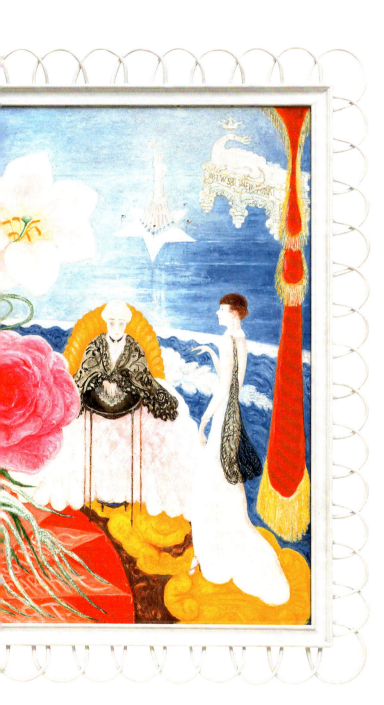

Stettheimer's masterpiece, *Family Portrait II* (32), once again assembles her family members in a seemingly fantastic setting. Three huge blooms in pink, red, and white dominate the picture's center. The three sisters and their mother have gathered on a colorful carpeted terrace. Towering in the blue background, where sea and sky blend together, are ethereally delineated, white New York landmarks. On the right, Carrie stands relaxed with a cigarette in front of her mother's solitaire table. On the left, Ettie reclines in her reading chair, and behind her is Florine in a black pant suit, with a red shawl and red shoes, reddish hair, and a palette in her hand—but without an easel. With its outsize flowers the painting appears to depict a floating never-never land. You feel that you are being allowed to observe these eccentric women in Paradise: surreal, theatrical, heavenly, timeless.

KARIN ALTHAUS *is a curator at the Städtische Galerie im Lenbachhaus und Kunstbau, in Munich, responsible for the nineteenth century and the New Objectivity.* **SUSANNE BÖLLER** *is an associate curator at the Lenbachhaus. She earned her doctorate in 2019 with a dissertation on "American students at the Munich Academy of fine arts, 1870–1887. Aesthetic strategies in a transcultural context". In 2014 they curated together the first comprehensive retrospective of Florine Stettheimer's work outside the United States.*

1 Parker Tyler, *Florine Stettheimer: A Life in Art*, New York 1963, p. 72.

2 Elisabeth Sussman and Barbara J. Bloemink (eds.), *Florine Stettheimer: Manhattan Fantastica*, exh. cat. The Whitney Museum of American Art, New York 1995, p. 65.

3 Carl van Vechten, "Pastiches et Pistaches. Charles Demuth and Florine Stettheimer," in: *The Reviewer* 2 (February 1922), pp. 269 f.

4 Henry McBride quotes sporadically from Florine Stettheimer's diary; the relevant pages do not appear to have survived. See Henry McBride, *Florine Stettheimer*, exh. cat. The Museum of Modern Art, New York 1946, p. 13.

5 The picture is dated 1907, however the diary entry recording the start of a "Flora" dates from December 1912; the quote is from January 1913; Emily D. Bilsky, in: Matthias Mühling, Karin Althaus, and Susanne Böller (eds.), *Florine Stettheimer*, exh. cat. Städtische Galerie im Lenbachhaus und Kunstbau, Munich 2014, p. 58.

6 Diary entry quoted in Barbara Bloemink, *The Life and Art of Florine Stettheimer*, New Haven, Conn., and London 1995, p. 43.

7 She also wrote a libretto, first in French, then in English, reproduced in Irene Gammel and Suzanne Zelazo (eds.), *Florine Stettheimer: Crystal Flowers. Poems and a Libretto*, Toronto 2010, pp. 136–39.

8 Stettheimer 2010 (see note 7), p. 131; on the style and interpretation of Stettheimer's poems see: Lesley Higgins, "American Minimalists. Dickinson, Williams, Stettheimer," in: *Florine Stettheimer. New Directions in Multimodal Modernism*, Irene Gammel, Suzanne Zelazo (eds.), Toronto 2019, p. 119–139.

9 Ibid., pp. 133 f.

10 "French Artists Spur on an American Art, Part IV," in: *The New York Tribune*, October 24, 1915, part IV.

11 McBride 1946 (see note 4), p. 10.

12 Ibid., pp. 43, 45.

13 Stettheimer 2010 (see note 7), p. 105.

14 Bloemink 1995 (see note 6), pp. 120–23.

15 Paul Rosenfeld, "The World of Florine Stettheimer," in: *The Nation* 134 (May 1932), p. 522.

16 Steven Watson, *Strange Bedfellows. The First American Avant-Garde*, New York, London, and Paris 1991, pp. 49 f.

17 Patricia Allmer and John Sears devoted an exhibition to the importance of photography for the reception of *Four Saints*. See Patricia Allmer and John Sears, *4 Saints in 3 Acts. A snapshot of the American avantgarde in the 1930s*, Manchester University Press, The Photographers' Gallery 2017.

18 Quoted from Bloemink 1995 (see note 6), p. 186.

33 Florine Stettheimer, ca. 1917–20; photo: Peter A. Juley & Son

BIOGRAPHY

Florine Stettheimer

1871–1944

1871 Florine Stettheimer is born on August 19 in Rochester, New York. Both her mother Rosetta Walter and her father Joseph Stettheimer are from Jewish banking families that had immigrated to the United States from Germany and Holland in the early nineteenth century. She has three older siblings—Stella, Walter, and Caroline (Carrie)—and will come to have a younger sister Henrietta (Ettie).

1875–1886 Shortly after Ettie's birth her father abandons the family, and around 1881 Rosetta moves with her children to Stuttgart. Florine attends the Prie, sersches Institut for upper-class girls and receives first instruction in drawing from its director, Sophie von Prieser.

1887–1889 The family moves to Berlin, where Florine is again instructed in drawing.

1890 The Stettheimers return to New York, where they take their place among the Jewish aristocracy. Rosetta Stettheimer and her children are supported by wealthy family members. Stella and her brother Walter both marry and move to California. Carrie, Ettie, and Florine remain un-married, and will live with their mother until the latter's death in 1935. Carrie becomes mainly responsible for household matters, Florine trains to be a painter, and Ettie studies philosophy and literature.

1892 Florine Stettheimer studies at the Art Students League in New York, working in a studio in the Beaux-Arts Building on Bryant Park, 80 West 40th Street. The curriculum is patterned after that of the Paris art schools. Women, who make up the majority of the students, draw after plaster casts and nude female models.

1895 In spite of extended stays in Europe, Stettheimer is elected "corre-sponding secretary of the League's governing board," and in 1900 will be permitted to participate in the exhibition marking the 25th anniversary of the League's founding.

1898–1914 Until the outbreak of the First World War, Rosetta Stettheimer and her daughters enjoy repeated extended sojourns in Italy, Germany, and France, avidly participating in all things cultural. In 1903 Ettie earns a

34 Florine, Carrie and Ettie Stettheimer (left to right), ca. 1914, photo collage

35 Florine's bedroom in the Alwyn Court Building, after 1926

doctorate at the University of Freiburg with a dissertation on William James. She will later publish two novels: *Philosophy*, in 1917, and *Love Days*, in 1923, under the pseudonym Henrie Waste. Florine receives instruction in painting and visits museums, exhibitions of contemporary art, galleries, and artists' studios. In Munich she admires the Alte Pinakothek, Franz von Lenbach, and Franz von Stuck, and becomes familiar not only with *Jugendstil*, but also (at the Galerie Thannhauser and elsewhere) with the Futurists and German Expressionists. In 1912/13 she paints a "Flora" in the neo-Rococo style (2) and also a portrait of her sister Ettie in a white dress inspired by James McNeill Whistler. In Paris she is impressed by the paintings of Édouard Manet, Paul Cézanne, and Claude Monet. Works by the Pointillists and the Fauves, especially Henri Matisse, will greatly influence her own painting.

The Stettheimer sisters enjoy taking part in Carnival and Fasching balls in Paris and Munich. Florine has numerous admirers, among them James Loeb, the son of a New York banker, publisher of the Loeb Classical Library, and collector of antique sculpture in Munich.

On June 8, 1912, in Paris, the Stettheimers attend a performance of Sergei Diaghilev's Ballets Russes, with sets by Léon Bakst and danced by Vaslav Nijinsky. The innovative dance theater makes a lasting impression on Florine; Nijinsky will subsequently appear in her pictures in various roles, and she will spend years creating a libretto and costumes for a ballet of her own, *Orphée of the Quat'z'Arts*, that will never be staged.

In 1912 The Stettheimers leave Paris and travel via Biarritz to Spain. There Florine is awed by the paintings of Titian and Velázquez, but is less impressed by El Greco, then being rediscovered, or by the work of her Spanish contemporaries.

1914 The outbreak of the First World War finds the Stettheimers in Bern. In September they return by way of Paris to New York, where they will spend the rest of their lives.

1914–1916 During the war New York becomes home to many returning Americans and expatriate Europeans, including numerous members of the Parisian avant-garde. Marcel Duchamp, Francis Picabia, Albert and Juliette Gleizes, Gaston and Isabelle Lachaise, Elie Nadelman, Leo Stein, Georgia O'Keeffe, Alfred Stieglitz, Edward Steichen, Henry McBride, Carl van

Vechten and others frequent the salon in the Stettheimers' Upper West Side apartment. In summer they host parties and picnics at their rented country houses. Stettheimer's art mutates from floral still lifes to portraits of family members and friends. *Family Portrait I* (3) combines both genres.

1916 In September Stettheimer has her first and only one-woman show at M. Knoedler & Co., curated by Marie Sterner. For her paintings, the majority of them in a Fauvist style inspired by Matisse, she creates a setting resembling the family apartment. Discouraged by the scarce public and critical reception, from now on she will show her work only in group exhibitions. She also hits upon the idea of throwing "birthday parties" for her newly finished works, attended by friends in either her salon or her studio. The Ballets Russes give performances in New York, and Stettheimer befriends the dancer Adolph Bolm, who campaigns (unsuccessfully) for a staging of her ballet *Orphée of the Quat'z'Arts*.

1917 Stettheimer begins to paint the family's parties and country excursions and her artist friends in a radically changed style. She now depicts elegant, fragile figures in radiant colors in colorful settings. Along with its Rococo reminiscences, her work is influenced by 1920s fashions, magazine illustrations and the painting of artist friends like Elie Nadelman and Adolfo Best-Maugard. She now regularly exhibits with the newly founded Society of Independent Artists (1917–1926).

1920 Stettheimer is one of the founding members of the Société Anonyme Inc., along with Katherine Dreier, Marcel Duchamp, and Man Ray, but does not participate in its exhibitions. Along with pictures of her family and friends, she paints multi-figured popular amusements. Her painting *Lake Placid* (15), shown at one of the Independent Artists exhibitions, is critically acclaimed.

1921 Alfred Stieglitz visits her studio. Excited by her work, he will henceforth beg her repeatedly to consent to a solo exhibition at his gallery, but each time she turns him down. Gallerists like Carl Sprinchorn and Julien Levy are similarly rebuffed.

1923 Stettheimer's studio in the Beaux-Arts Building is considered the *dernier cri* of the New York art scene. Edward Steichen uses it as the setting for photographs of Mr. and Mrs. Rudolph Valentino and other models for *Vogue* and *Vanity Fair*.

1924 At the Carnegie International, Florine Stettheimer's painting *Russian Bank* (1921) captivates the critics. She is celebrated as the only artist with an individual perspective. Reviews of her contributions to other exhibitions in the 1920s are generally positive.

1926 The Stettheimer sisters and their mother move into a luxurious apartment at Alwyn Court, 182 West 58th Street, a block north of Carnegie Hall.

1928 The composer Virgil Thomson first presents his opera *Four Saints in Three Acts*, to a libretto by Gertrude Stein, in Carl van Vechten's salon, then again at the Stettheimers'. Thomson is charmed by Florine Stettheimer's paintings, and at his instigation she will spend the next few years designing stage sets and costumes for the opera.

1929 Stettheimer begins her series of four *Cathedrals*, featuring core themes of modern life in New York. Henry McBride emphasizes the works' modernity, and Paul Rosenfeld now numbers Stettheimer, along with Georgia O'Keeffe and Peggy Bacon, among the country's most important women artists.
The financial crisis has little effect on the Stettheimers' standard of living.

1932 The *Cathedrals of Fifth Avenue* (23) is exhibited at The Whitney Museum of American Art in its *First Biennial Exhibition of Contemporary American Paintings*.

1934 The premiere of *Four Saints in Three Acts* takes place at the Wadsworth Atheneum in Hartford, Connecticut. The performance will be remembered as a milestone in American theater, and the critics are not least impressed by Stettheimer's contribution.
Stettheimer is represented in the show *Modern Works of Art*, marking the fifth anniversary of the founding of the Museum of Modern Art.

36 Florine Stettheimer, August 19, 1931; photo: Arnold Genthe

1935 Florine and Ettie Stettheimer undertake an extensive tour of California. After their return their mother Rosetta dies. The sisters give up the apartment in Alwyn Court. Ettie and Carrie move into the Dorset Hotel, Florine into a larger studio in the Beaux-Arts Building that she decorates in white and gold with lace and cellophane. From now on she will host only smaller parties.

1938 Stettheimer is invited along with Georgia O'Keeffe to participate as one of only two women artists in an overview of American art to be shown in New York and Paris, but shortly before the opening at the Museum of Modern Art she withdraws her consent. She is not pleased with the planned presentation. After much pleading by the curator Tom Mabry ("an American show in Paris is unthinkable without you"), she ultimately agrees to send her *Asbury Park South* (19) to Paris's Musée du Jeu de Paume.

1942 She begins painting *The Cathedrals of Art* (25), highlighting the rivalries in the New York art world. The picture will remain unfinished.
In December she shows her *Ettie Stettheimer* and *Duchamp & Rrose Sélavy* in the Museum of Modern Art's exhibition *Twentieth Century Portraits*.

1943 Florine Stettheimer is diagnosed with cancer. In the summer she is released from Roosevelt Hospital and again takes up her work and her social life.

1944 Florine Stettheimer dies in New York Hospital on May 11 at the age of 73. She works on *The Cathedrals of Art* and a projected ballet, *Pocahontas*, up until the end. Carrie dies only six weeks later.
In her will, Florine leaves all her artworks to her sisters, with the assurance that they are familiar with her wishes. Conflicting reports insisting that Stettheimer directed that her paintings be either destroyed or buried with her cannot be verified, and may simply be the stuff of legend.
After Florine's death, Ettie Stettheimer asks for advice from the photographer Carl van Vechten and the art dealer R. Kirk Askew Jr. about the distribution of her sisters' paintings to American museums. No single institution is willing to take her entire oeuvre, so ultimately a number of museums will come to own one or two paintings, which over time will enhance recognition of her work and make possible their broader reception.

37 Carrie Stettheimer with Ettie as "Medusa", October 8, 1932;
photo: Carl van Vechten

1946 A first retrospective of Stettheimer's works is presented at the Museum of Modern Art, initiated by Marcel Duchamp, curated by Monroe Wheeler, and with a catalogue text by Henry McBride. The show subsequently travels to the De Young Memorial Museum in San Francisco and to the Arts Club of Chicago.

1948 On September 25 Ettie, together with the family's attorney Joseph Solomon, sprinkles Florine's ashes in the Hudson River.

1955 TO DATE. On Ettie's death in 1955, "The Florine and Ettie Stettheimer Papers" are placed in the Beinecke Rare Book and Manuscript Library at Yale University, New Haven, and in 1967 more of Florine Stettheimer's papers as well as the single largest collection of her artworks are bequested to Columbia University, New York.

Parker Tyler's extensive biography of Florine Stettheimer was published in 1963. Her work was rediscovered in 1980 thanks to a major exhibition in Boston curated by Elisabeth Sussman. At that time the noted feminist art historian Linda Nochlin coined the term "Rococo subversive" to describe her art.

Since then, interest in the study and presentation of Florine Stettheimer's life and work has grown, often with a feminist or queer focus. The year 1995 brought a double breakthrough: Sussman again curated a large show, under the title *Manhattan Fantastica*, this time at The Whitney Museum of American Art, and Barbara Bloemink published a comprehensive monograph (she is currently compiling a catalogue raisonné, which is nearly complete). The first Florine Stettheimer exhibition to be presented outside the United States was mounted at Lenbachhaus Munich in 2014. It was met with great interest on the part of the public and received broad critical acclaim. A number of further presentations and publications followed, and it now appears that Stettheimer's work is here to stay in the minds of both scholars and the art-loving public.

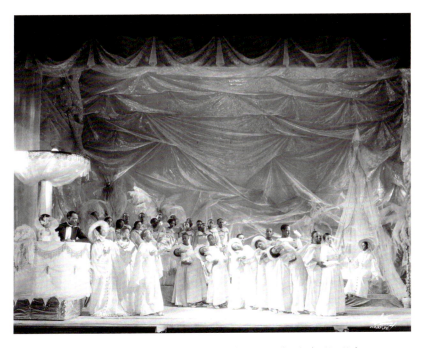

38 Performance of the opera *Four Saints in Three Acts* on March 10, 1934, White Studio, New York

39 The Florine Stettheimer Retrospective at the Museum of Modern Art, New York, 1946

40 The Studio in the
Beaux-Arts Building, 1944;
photo: Peter A. Juley & Son

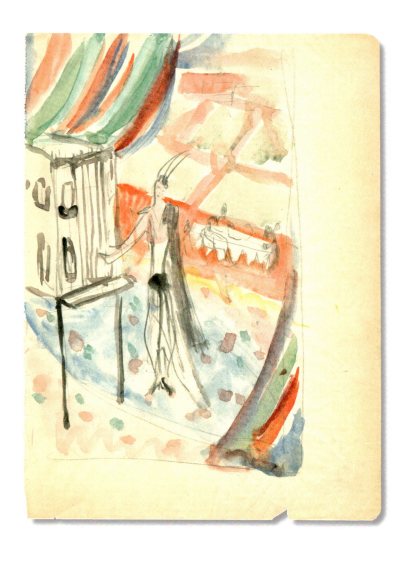

Study for *Portrait of My Sister, Carrie W. Stettheimer*, ca. 1923,
watercolor, Florine Stettheimer Papers, Rare Book and Manuscript
Library, Columbia University, New York

ARCHIVE

Drawings, Documents and Poems
ca. 1892–1944

In her groundbreaking essay "Why Have There Been No Great Women Artists?" (1971) Linda Nochlin emphasized the importance of the training afforded to women artists. Study of the nude human body has always been considered fundamental for every professional painter and sculptor. Yet until the early twentieth century, in most places women were not allowed to attend academies and draw there from the (mostly male) nude. It was only thanks to private art schools, which sprang up as alternatives in the last quarter of the nineteenth century in the United States and around 1900 in Europe, that they were permitted to study the nude body. The nudes among Stettheimer's drawings are exclusively female, presumably produced during her studies at New York's Art Students League, in which she enrolled in 1892.

2

Florine Stettheimer was an extremely conscientious and candid diarist. She lists and comments on museum, theater and restaurant visits, passes forthright judgments, repeats gossip, rhapsodizes, blasphemes, complains, and catalogues the doings of celebrities and the guests at her salon. All this makes her diaries a highly interesting historical document. The volumes from the years 1906 to 1944 are in the Beinecke Rare Book & Manuscript Library at Yale University, as part of the Stettheimer papers presented to the library by her sister Ettie. Before surrendering them, however, Ettie neatly cut out a large number of pages: presumably she censored Florine wherever she expressed her anger too violently or related the details of a flirtation.

On July 18, 1909, Florine Stettheimer visited the Franz von Lenbach villa in Munich, and was enraptured: "We visited Lenbach's house—it is wonderful—

1 *Nude Study, Standing, Back View*, undated
Charcoal on paper, Art Properties, Avery
Architectural & Fine Arts Library, Columbia University,
New York. Gift of Joseph Solomon, 1972

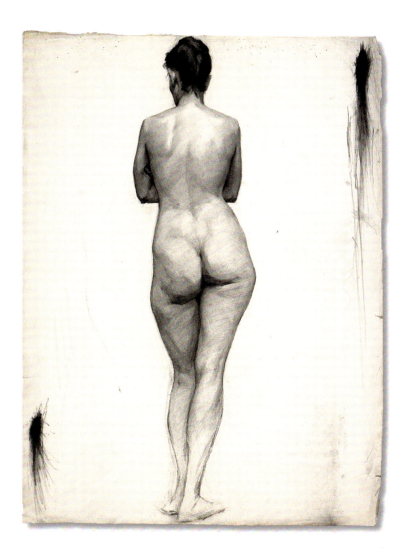

18ᵗʰ just returned from Schau-
spielhaus - The Understands un
his judgnot - He acts better
than he writes - A wretched
play - and so vulgar - It was
funny tho' it was, but meant
to be. And it smelt - so -
I don't think I shall go
again - The bad air & bad
plays disagree with me.
We visited Lenbachs house - It
is wonderful - so many beautiful
things, and he displayed exqui-
site taste in having the rooms
fitted out - the ceilings and
some of the doorways are beau-
tiful.
At Lenbachs gall. were Wilke
and Regnier - I can't stand

2

so many beautiful things, and he displayed exquisite taste in having the
room fitted out—the ceilings and some of the doorways are beautiful."

3

*In Florine Stettheimer's comprehensive concept of art, poetry was a major
element. After her death, her sister Ettie published a private edition of 250
copies of unpublished poems Florine had at most shared with friends:* For
Florine's Friends and the Friends of Her Paintings. *The collection* Crystal
Flowers—*possibly so named with reference to the flowers Florine crafted her-
self out of glass beads—reflects and expands on the subjects of her paintings:*

2 Diary entry for July 18, 1909, Yale, Beinecke Rare Book & Manuscript
Library, Series II, Diaries, Box 7, Folder 110

3a Mother Asked
Yale, Beinecke Rare Book & Manuscript Library, Series III, Writings,
Box 8, Folder 135

children's rhymes (for adults), nature, flora and fauna, everyday events, foods, Americana, moods, people, communications to friends, and diary-like material, big-city life, luxury articles, and art. She subsumes the stuff of her day-to-day existence as a well-situated New Yorker in the first strophe of My Attitude Is One of Love, with a charming sentence in enjambement.; in the second strophe she strings together rhymed wishes, self-ironically self-indulgent.

Seen only superficially, her verses seem carefree and simple. Yet, from her versatile handling of formal means one sees how Stettheimer creates clever wordplay in casual, nonchalant rhymes. Her choice of words is precise; each verse is filled with rich visual rhetoric, and leaves ample room for interpretation between the lines, so that even a short strophe is expressive of strikingly vivid life experience. Stettheimer generally eschewed periods, so that the ends of her poems remain open.

The poems are undated as a rule, but next to Mother Asked, below right, the place and time of its writing are noted: "August, Monmouth B[each])." The "Stetties" had rented a cottage there in the summer of 1920.

[Mother Asked]
Mother asked
What are you making now?
I was sewing silver fringe
onto stiff taffeta
pale blue
shot with gold
the color of the sunglinted sea
that was breaking
and foaming
below our balcony –
I answered
I think a bathing suit
or perhaps
a moonwrap

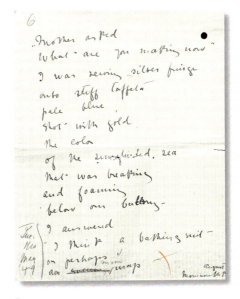

3a

[My Attitude Is One of Love]
My attitude is one of love
is all adoration
for all the fringes
all the color
all tinsel creation

I like slippers gold
I like oysters cold
and my garden of mixed flowers
and the sky full of towers
and traffic in the streets
and Maillard's sweets
and Bendel's clothes
and Nat Lewis hose
and Tappé's window arrays
and crystal fixtures
and my pictures
and Walt Disney cartoons
and colored balloons

3b

3b My Attitude Is One of Love
Yale, Beinecke Rare Book & Manuscript Library, Series III, Writings, Box 8, Folder 135
4a Peter A. Juley & Son, *Florine Stettheimer's studio in the Beaux-Arts Building, with the painting* Sun *above the commode*, 1944
4b Furniture designs, ink on paper
Both illustrations: Florine Stettheimer Papers, Rare Book & Manuscript Library, Columbia University, New York

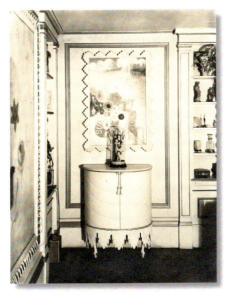

4a 4b

4

Florine Stettheimer turned her studio and her living rooms into opulent set-
tings for her art and her guests. In her poem The Unloved Painting, *one pic-*
ture begs its creator to be allowed to remain at home in its accustomed elegant
surroundings. With specially made frames for her paintings and furnishings
she designed herself, Stettheimer created an eccentric counterpart to the omni-
present White Cube for the display of modern art and to such architectural
trends as the Bauhaus style. For her studio in the Beaux-Arts Building, docu-
mented by Ettie Stettheimer together with the photographer Peter A. Juley
after Florine's death, she had conceived a white commode with gold trimming
that harmonized perfectly with the room's paneling and stuccowork and with
the frame of the painting Sun *(1931). In her rooms she contrasted the neo-*
Rococo style with the use of the most modern materials, for example curtains
of cellophane.

SOURCES

Published by
Hirmer Verlag GmbH
Bayerstraße 57–59
80335 Munich
Germany

Cover illustration: *Portrait of My Sister,
Carrie W. Stettheimer* (detail), 1921, see page 49
Double page 2/3: *Spring Sale at Bendel's* (detail),
1942, see page 36
Double page 4/5: *The Cathedrals of Art* (detail),
1942, see page 45

ISBN 978-3-7774-3632-6
Printed in Germany

www.hirmerpublishers.com

TRANSLATION
Russell Stockman

COPY-EDITING/PROOFREADING
Jane Michael, Munich

PROJECT MANAGEMENT
Tanja Bokelmann, Munich

DESIGN/TYPESETTING
Marion Blomeyer, Rainald Schwarz, Munich

PRE-PRESS/REPRO
Reproline mediateam GmbH, Munich

PRINTING/BINDING
Passavia Druckservice GmbH & Co. KG, Passau

Bibliographic information published by the
Deutsche Nationalbibliothek The Deutsche
Nationalbibliothek lists this publication in the
Deutsche Nationalbibliografie; detailed
bibliographic data are available on the Internet
at http://dnb.dnb.de.

This publication was made possible through the
kind support of the Städtische Galerie im
Lenbachhaus und Kunstbau München, Munich.

LENBACHHAUS

THE GREAT MASTERS OF ART SERIES

ALREADY PUBLISHED

WILLEM DE KOONING
978-3-7774-3073-7

LYONEL FEININGER
978-3-7774-2974-8

PAUL GAUGUIN
978-3-7774-2854-3

RICHARD GERSTL
978-3-7774-2622-8

JOHANNES ITTEN
978-3-7774-3172-7

VASILY KANDINSKY
978-3-7774-2759-1

ERNST LUDWIG KIRCHNER
978-3-7774-2958-8

HENRI MATISSE
978-3-7774-2848-2

PAULA MODERSOHN-BECKER
978-3-7774-3489-6

LÁSZLÓ MOHOLY-NAGY
978-3-7774-3403-2

KOLOMAN MOSER
978-3-7774-3072-0

ALFONS MUCHA
978-3-7774-3488-9

EMIL NOLDE
978-3-7774-2774-4

PABLO PICASSO
978-3-7774-2757-7

EGON SCHIELE
978-3-7774-2852-9

FLORINE STETTHEIMER
978-3-7774-3632-6

VINCENT VAN GOGH
978-3-7774-2758-4

MARIANNE VON WEREFKIN
978-3-7774-3306-6